Shari,

You take your
incredible sense of
fashion taste for
granted. I have learned a
appreciation for why it is in
to indulge the fashion - from g
and I'll always take all friends
when I ___ - and reflect upon it fondly -
STOP!
Love, light,
Mary Ann

by Diana Vreeland

Why Don't You

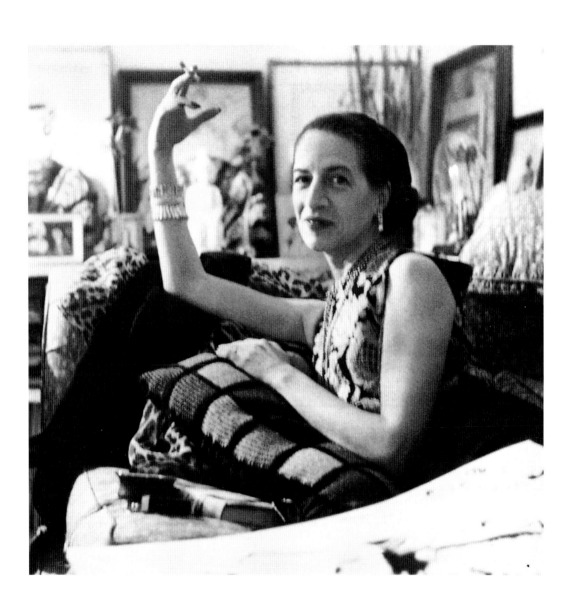

DIANA VREELAND BAZAAR YEARS

Including 100 audacious *Why Don't Yous...?*

JOHN ESTEN

UNIVERSE

HALF TITLE PAGE:
Alexey Brodovitch innovatively incorporated Mrs. Vreeland's hand in a photograph
to illustrate her column for the July 1937 issue of *Bazaar* magazine. Courtesy the Hearst Corporation.
OPPOSITE TITLE PAGE:
Horst photographed Mrs. Vreeland in her Park Avenue living room in the mid-1950s.
Courtesy Staley/Wise Gallery.
OPPOSITE DEDICATION PAGE:
"Disraeli conferring with Queen Victoria" is how photographer Louise Dahl-Wolfe described the
photograph of Mrs. Vreeland and herself in her studio at 58 West 57th Street.
Courtesy Staley/Wise Gallery.

First published in the United States of America in 2001 by

UNIVERSE PUBLISHING

A division of Rizzoli International Publications, Inc.
300 Park Avenue South
New York, NY 10010

2001 2002 2003 2004 2005 2006/ 10 9 8 7 6 5 4 3 2 1

Library of Congress Control Number:
2001091977

ISBN 0-7893-0627-1(hc)

Credits:

Book Design: John Esten
Digital Composition: Mary McBride
Printed in China

*[Y]ou gotta have style.
It helps you get
down the stairs.
It helps you get
up in the morning.
It's a way of life.
Without it
you're nobody.
I'm not talking about
a lot of clothes.*

—Mrs. Vreeland, in ROLLING STONE

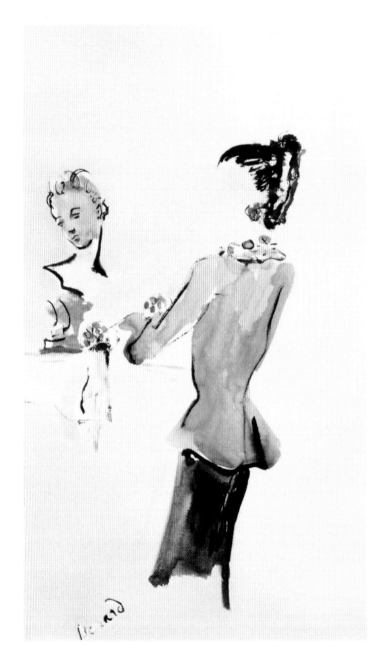

The May 1941 "Editor's Guest Book" of *Bazaar* magazine announced that: "for the first time in three years, our Fashion Editor DIANA VREELAND has been prevailed upon to revive her kaleidoscopic 'Why Don't You…? column.'" Artist Christian Bérard was commissioned to make a watercolor portrait of the editor to accompany the announcement. WATERCOLOR: courtesy the Hearst Corporation.

CONTENTS

FOR
CATHARINE STEWART DIVES

who introduced me to Mrs. Vreeland

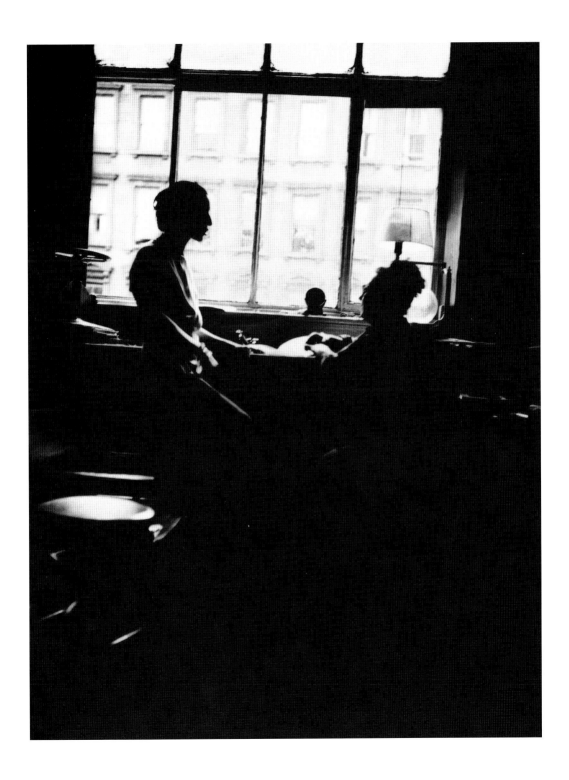

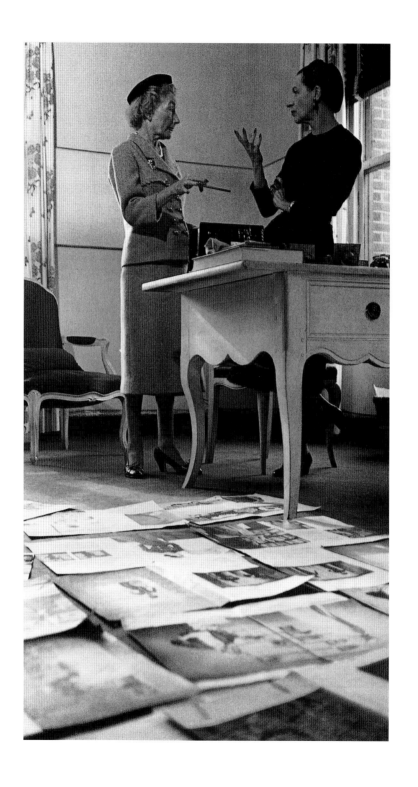

BAZAAR YEARS

*I was always fascinated by the absurdities
and the luxuries and the snobbism
of the world fashion magazines showed.
Of course, it's not for you—now.*

—D.V.

Artist Mike Wolfe, the husband of photographer Louise Dahl-Wolfe, often amusingly remarked that "Dee-Ann wasn't an editor, she was an actress!" Mike was right. Diana Vreeland always appeared center stage, playing her favorite role, the fashion editor. Her now legendary career was a perpetual performance, and she was dazzling. Her premier role at *Harper's Bazaar* magazine had a long run, and her instinct, talent, and taste helped contribute to make the magazine the best periodical of its day.

When Carmel Snow transferred her allegiance from *Vogue* to *Harper's Bazaar* in 1933, her first inclination was "to get fresh air into the book." Almost immediately, the innovative editor-in-chief began to assemble a new staff to reshape the "dull and monotonous" sixty-six-year-old magazine. One member of the new staff, the socialite Diana Vreeland, would become the greatest fashion editor ever. Her renown has since eclipsed the woman who discovered her.

Mrs. Snow recalled that "the first of my 'discoveries'" occurred soon after being shown some photographs by Hungarian photographer Martin Munkacsi, who was on assignment in the United States for the *Berlin Illustrated News*. Captivated by the spontaneity and naturalness of Munkacsi's work, Mrs. Snow commissioned the photographer to reshoot a swimwear feature that had been formerly shot in a studio setting. Munkacsi decided the swimsuit should be photographed in the setting for which it had been designed—out-of-doors. The resulting picture, of an American girl running along a beach, changed photographic history—Munkacsi had made fashion photography move!

The following year, the new editor-in-chief made a second discovery: Alexey Brodovitch, a graphic designer who had recently arrived from Europe and was exhibiting his work at the Art Directors Club. Upon viewing the exhibition, Mrs. Snow quickly perceived that the Russian had developed a revolutionary concept in graphic design: "pages that 'bled,' beautifully cropped photographs, typography and

Bazaar editor-in-chief Carmel Snow meeting with Diana Vreeland, senior fashion editor, in her Madison Avenue office. Pages of proofs for a future issue of the magazine are seen neatly arranged in the foreground. PHOTOGRAPH: Walter Sanders, 1952, ©Time Pix.

design that was bold and arresting." That same evening, Mrs. Snow signed a provisional contract with the émigré-art director, who promptly began to redefine the visual content and overall look of the magazine and turned it into the most avant-garde publication in the country.

Another addition to the *Bazaar* staff was Daisy Fellows, a Franco-American heiress who, according to the August 1933 issue of the magazine, had "launched more fashions than any other woman in the world." Infatuated with her style, Mrs. Snow "persuaded" the Honorable Mrs. Reginald Fellows to become the Paris editor of *Harper's Bazaar*. Her combined social and artistic connections enabled the magazine to become an integral part of the rarified, creative capital of fashion, Paris.

Resigning after a two-year tenure, Daisy Fellows's sometimes unorthodox fashion reportage was exactly the breath of fresh air the editor wanted for her magazine, and was a preface for what was to come.

One of Carmel Snow's most auspicious discoveries was a rediscovery. She had featured the stylish socialite, Mrs. T. Reed Vreeland in a Munkacsi photograph, striding down Park Avenue wearing a gray suit and dashing nutria cape, in the January 1936 issue of the magazine. The editor-in-chief later caught sight of Mrs. Vreeland dancing one night on the Viennese Roof of the St. Regis Hotel, wearing a white-lace Chanel dress with a bolero top and roses strategically tucked into her blue-black hair. "Dee-Ann" (as she always pronounced her name) had just returned from living in London with her banker husband and two sons.

Ever since Daisy Fellows had abdicated her position from the magazine, Mrs. Snow had been looking for a replacement, "someone who would make news for *Harper's Bazaar*." In Diana Vreeland she sensed she had found that "someone." The next morning Mrs. Snow telephoned and invited her to join the staff of the magazine. Mrs. Snow remembered that "she reflected for us the new world of the International Set."

Though greatly flattered by the job offer, Mrs. Vreeland had some reservations, explaining that she had never worked, never seen the inside of an office, and rarely dressed until lunchtime.

"Well, you do know a lot about clothes," Mrs. Snow succinctly remarked.

"That, of course, I do know. I've dedicated hours and hours of detailed time to my clothes."

"All right, well, you come and work here and see how it develops," suggested the editor-in-chief. It developed into a twenty-five-year working relationship that constantly made headlines for *Harper's Bazaar*.

Diana Vreeland began her *Bazaar* career writing a monthly column of audacious advice for living a more fashionable life entitled "Why Don't You…?" The column contained flights from the humdrum existence of a country in the depths of the Great Depression, such as tying tulle on the wrists instead of wearing bracelets, rinsing a blond child's hair in dead champagne to keep its gold, turning an old ermine coat into a bathrobe, or painting a map of the world on a boy's nursery walls so he won't grow up with a provincial point of view. "They were all very tried and true ideas, mind you," she unassailably said.

The "absurdities," as the fledgling editor later called them, were enthusiastically read, repeated, and, of course, parodied: one "Why Don't You...?" with a double meaning appeared on bulletin boards of men's locker rooms across the country. When S. J. Pearlman maliciously satirized them in *The New Yorker*, Mrs. Snow had a "flaming row" with the magazine's editor, Harold Ross, "which put a stop to *Bazaar* parodies for a while."

One of the early columns produced fan mail for the new editor—from William Randolph Hearst, the owner of the magazine, no less. Mrs. Vreeland happily recalled his handwritten note: "Dear Miss Vreeland, it is always a pleasure to read your columns. I reread them all the time. I am a particular admirer of yours." She was thrilled, wryly remarking, "Don't you love the 'Miss?'"

Hearst also owned the building at 572 Madison Avenue that housed the staff of *Harper's Bazaar*. The command center of the magazine was at the end of a narrow hall, usually lined with staff members waiting their turn to see Mrs. Snow, whose office door was always open "except when I was getting a pedicure or firing someone."

"It was like going into fresh fields full of apple blossoms when you went into Carmel's office those early days," the new editor remembered. "There was always a divine smell in the room. The windows were always open, as if to everything new. Everything was so light, so sure, so concentrated."

Just six months after entering Carmel Snow's flower-filled office for the first time, Diana Vreeland made headlines herself—Mrs. Snow

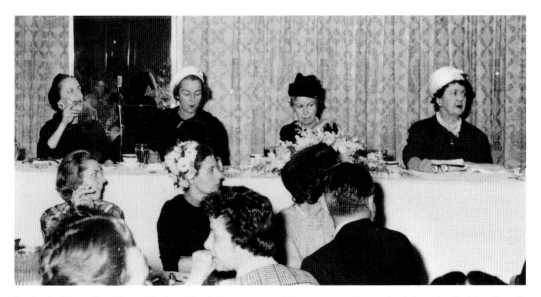

Senior fashion editor Diana Vreeland (far left) represented *Bazaar* magazine on the dais at the Fashion Group's showing of the Fall Import Collection at the monthly luncheon meeting on March 11, 1960. Other members of the fashion press (from left to right) include Sally Kirkland, *Life* magazine; Eugenia Sheppard, *New York Herald Tribune*; and Jessica Daves, *Vogue* magazine. PHOTOGRAPH: courtesy the Fashion Group.

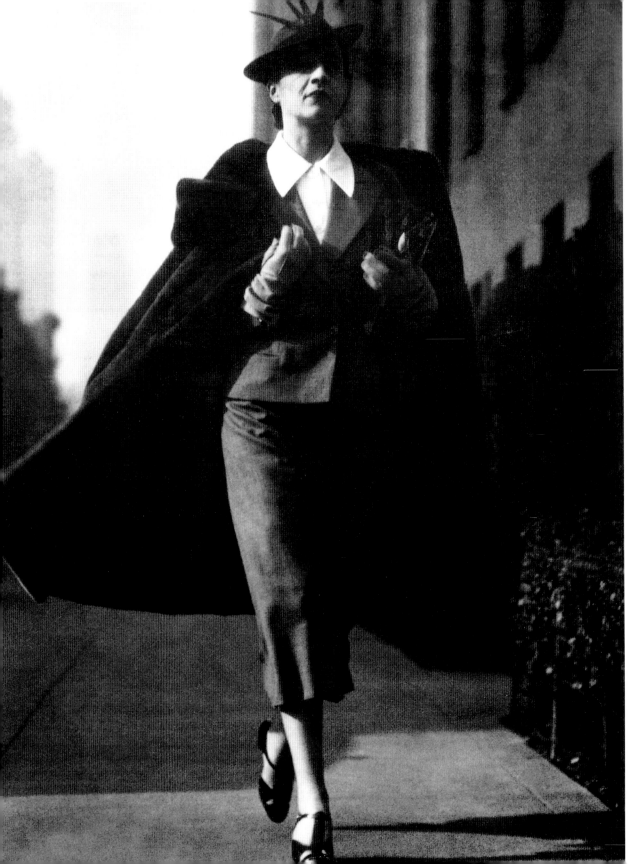

The first column of "Why Don't You . . . ?" written by Diana Vreeland appeared in the March 1936 issue of *Bazaar*. Her first suggestion of zipping an evening dress was a revolutionary one. Schiaparelli had just designed dresses using zippers (before that time, clothing had been secured with buttons or hooks) that made dressing and undressing easier. Art director Alexey Brodovitch's design for the page was equally revolutionary with the type set on a slant. OPPOSITE: Carmel Snow had featured Mrs. T. Reed Vreeland in the January 1936 issue of *Bazaar*, three months before Mrs. Snow invited her to join the staff of the magazine. Munkacsi photographed the stylish socialite wearing a gray suit and nutria cape. PHOTOGRAPH: Joan Munkacsi/courtesy Howard Greenberg Gallery.

WHY DON'T YOU . . .

ZIP YOURSELF INTO YOUR EVENING DRESSES?

WAFT A BIG BOUQUET ABOUT LIKE A FAIRY WAND?

WEAR A BOWLER?

STICK JAPANESE HAIR-PINS IN YOUR HAIR?

BUY A TRANSPARENT EVENING COAT?

OR A GERANIUM CHIFFON TOQUE?

OR BRIGHT FLANNEL GLOVES?

OR A BLACK BLOUSE?

EXPOSE YOUR FORTUNE IN AN ISINGLASS BAG?

HIDE YOUR HIPS UNDER AN ACCORDION-PLEATED JACKET?

WEAR FRUIT HATS?

CURRANTS?

CHERRIES?

appointed her to the position of fashion editor at the magazine. "[I]n those days the fashion editor was quite important. That is to say I wasn't a fashion editor—I was *the* one-and-only fashion editor," she declared afterward.

Bettina Ballard, Mrs. Vreeland's counterpart at the "other" fashion magazine—*Vogue*—included in her autobiography her firsthand observation of Mrs. Vreeland's unprecedented approach to editing for *Bazaar*:

Her concept of being a fashion editor is to create fashion for *Harper's Bazaar*, to motivate it, not simply to report on what Seventh Avenue has to offer. She saw only a few collections herself until the last few years, those of designers who she thought had a "look" of their own, such as B. H. Wragge's sports clothes. "My dear," she would say, "no one, but no one, can touch his American look—clothes with youth and energy, if you know what I mean. Clothes with breezes running through their seams!"

Her consistency has given a very personal look, not only to herself, but to the pages of *Harper's Bazaar* for many years, a look based on knowledgeable extravagance, imaginative perfection. Her affectations are so elevated that they make all others seem shoddy—the cultivated affectations of a highly individual and intelligent woman. Everything she does, everything she says seems to come from a cloud. "You know, don't you"—"that the Bikini is *only* the most important thing since the atom bomb" is a Diana statement made shortly after the war, not in a frivolous mood. To her it was a deep and important fashion truth. She was right—the Bikini has been a bombastic element in fashion ever since. [The bikini, designed by the French mechanical engineer Louis Réard, was presented at a 1946 fashion show in Paris. Mrs. Vreeland immediately dubbed it the "swoonsuit," remarking that it "revealed everything about a girl except her mother's maiden name."]

Her editors scour the market on Seventh Avenue and bring back the cream for her appraisal. On rehearsal days [when she selected clothes and accessories to feature in future issues of the magazine] she sits with her eyes far off on cloud number twelve and watches while the nervous editors put the clothes of their choice on the mannequins. Diana transforms these into the fashion look in which she believes at the moment, or she may discard a costume with a sweep of a well-massaged arm. With pure Dianaism, she describes what effect she wants. "This, my dear," pointing to a sequin sheath, "must look drowned," as if the word tasted of salt water. "You know what I mean, like a wet, wet mermaid sliding through the water," and she pulls the mannequin's hair down over her eyes, calls for jewels that drip stones, mesmerizes the girl into looking as if she were drifting into eternity and expects her young editor and the photographer to keep this image in their minds when photographing.

Working on a fashion photograph or a fashion show, Diana has never been content simply to present a costume; she must create the type of woman who might wear the costume, consider where she might wear it, possibly stop to ponder on the life story of the imaginary woman in the ready-made suit in front of her. Clothes are people to her, and her interest in them is deep and human. She is unique in the fashion editing field, a lone cry for an imaginative view on fashion. Her cry is often understood through some mysterious transference of image. I

heard her describing to a baffled hairdresser what look she wanted to achieve with the coiffure of a mannequin who was wearing a painfully simple white Balenciaga evening gown. "Twist the hair up, twist it out," gesturing graphically with her long pomegranate-red-nailed fingers and rolling her mouth to accentuate the movement she wanted, "let it float into space—if you know what I mean—way, way out, all the way to Outer Mongolia." And, almost as if a jinni had stepped out of a bottle and taken hold of his fingers, the little hairdresser twisted the mannequin's hair into Outer Mongolia. Looking at the model whose eyes had been made up like those of an ancient Egyptian princess, plus being sprinkled with Elizabeth Arden's sparkling crystals, Diana's reaction was, "There, my dear, at last you look natural—understandable—alive!" every word punctuated by a jutting lower lip. She was right. The girl looked like a natural product of Diana's imagination. She likes descriptive-sounding words and will suddenly turn to a young editor who wasn't even born in the Twenties and say, "I say, what this costume needs is *pezazz* [sic], do you get the idea?" and the young girl gets the idea.

It was new and original ideas that made *Harper's Bazaar* the best. "[I']m terrible on facts. But I always have an idea," Diana Vreeland admitted. "If you have an idea, you're well ahead!"

Many of Mrs. Vreeland's ideas influenced fashion trends: a black cashmere sweater worn as a uniform, the thong sandal, animal prints, wigs of artificial flowers (although Adolfo took credit for that), a snood instead of a hat, and black ballet slippers, which did not require pre-cious ration coupons during World War II.

During the war, gas rationing greatly restricted taking fashion photographs in distant locations. To photograph part of a spring 1943 issue outdoors, Diana Vreeland, with photographer Louise Dahl-Wolfe, Louise's two assistants, and a young model, Betty Bacall, traveled by train to St. Augustine, Florida, early in the year.

After photographing in and around the historic city for several weeks, frantically working whenever the rain let up, it was time for the editor and "crew" to return to New York. "We're in the middle of the war," she pointed out. "We can't get home. So every day, rain or shine, I walked to the railroad station for tickets home for five people.... It was always: 'come back tomorrow.' " Mrs. Vreeland quickly improvised: "Well, I've got a girl with me who's having a baby and I've got to get her to New York because she's not in good shape, she may lose the baby. And I loathe doing this in the middle of the war. It's wrong. But we've got to get back to New York." The ploy worked! The editor and crew boarded an overcrowded train that very night, "cool as cucumbers," she said.

Soon after returning to New York, Betty Bacall boarded a train going in another direction—Hollywood. The covers and other pages she posed for in *Harper's Bazaar* landed her a movie contract, along with a new first name, Lauren.

Two other models who appeared in the magazine under Diana Vreeland's aegis also traveled west with movie contracts under their belts. In the fifties, Suzie Parker, and then Ali McGraw, an assistant who had turned to modeling, began Hollywood careers after stints at *Bazaar*.

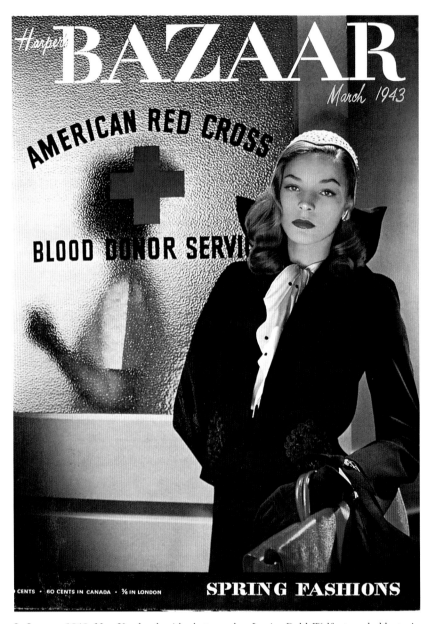

In January 1943, Mrs. Vreeland, with photographer Louise Dahl-Wolfe, traveled by train to St. Augustine, Florida, to photograph the cover and part of the March issue of *Bazaar* magazine. OPPOSITE: Dahl-Wolfe's photograph of model Betty Bacall posing "on the beach at St. Augustine where the U.S. Coast Guard stands duty with its dogs of war" wearing "a fresh dress of Everfast cotton." PHOTOGRAPH: courtesy Staley/Wise Gallery. ABOVE: The March 1943 cover by Dahl-Wolfe landed the young model a movie contract and new first name. COVER: The Hearst Corporation; final engraver's proof, courtesy the Museum at the Fashion Institute of Technology, gift of Louise Dahl-Wolfe.

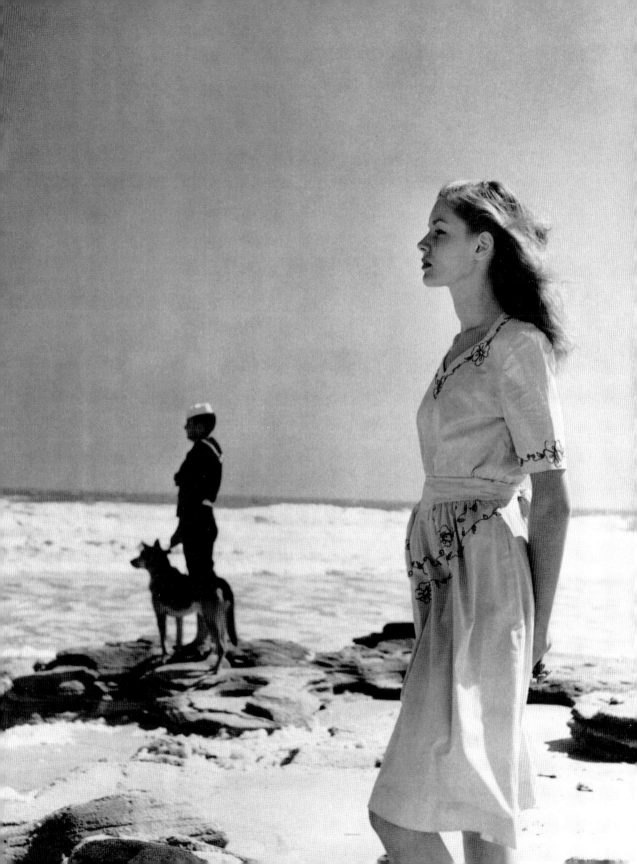

Mrs. Vreeland was no stranger to Hollywood. Kay Thompson caricatured the fashion editor in the delightfully outrageous "Think Pink" scene in the film *Funny Face*, a 1956 movie based on *Bazaar* magazine.

Although Mrs. Vreeland never appeared in her office until at least noon, she would call from her Park Avenue apartment to give directions to her assistant and others members at *Bazaar* all morning. The "skivvies," as she called them, were hard at work doing her bidding beginning at 9 a.m. Over the years, the changing roster of hand-picked, Vreeland-trained assistants and protégés who matriculated into successful careers in fashion and marriage became legion: Wendy Inglehart ("you know who I'm talking about—the Ingleharts—he was head of Grace Line, they were big polo people…,"); Lee Bouvier, who married a prince (Mrs. Vreeland advised Lee's sister Jacqueline Kennedy on her wardrobe as she prepared for her role as new chatelaine of the White House) and became Lee Radziwell; and Melanie Witt Miller, who graduated to the newly established *Junior Bazaar* and, like many skivvies, later became a fashion editor at other magazines.

While supervising photography sittings, either on location or in the studio, Mrs. Vreeland demanded perfection and innovation from the photographers she worked with. "I'm looking for the suggestion of something I've never seen," she was always quick to remind them. Munkacsi, Hoyningen-Huene, Louise Dahl-Wolfe, and, beginning in 1945, a new photographer she always called "Aberdeen"— Richard Avedon—never let her down.

Sometimes during a sitting Mrs. Vreeland was in front of the camera. "In Paris, long before I went into business, I used to pose for so many artists you can't imagine—always from the head down. It was known as 'figure modeling.' They never used my face, but I knew how to wear clothes and I've always adored to pose."

Diana Vreeland posed for Munkacsi and Louise Dahl-Wolfe, and both photographers did include her face. On many occasions, her beautiful, perfectly manicured hands were the highlight of Dahl-Wolfe's pictures. "Everything is in the hands. I have something of a fetish about them," Mrs. Vreeland admitted later.

Cecil Beaton, the discerning English photographer who carefully chronicled the first fifty years of twentieth-century style in his book *The Glass of Fashion*, enthusiastically wrote that "among the women whose vocations involve them with the world of fashion, none is more strikingly individual than Mrs. Vreeland of American *Harper's Bazaar*." Beaton observed further that Diana Vreeland's:

physical appearance is like an authoritative crane; and though, unlike that bird, she always stands upon two feet, she can and does give the marvellous illusion of balancing upon one. With her pelvis thrust boldly backwards at a forty-five degree angle, Mrs. Vreeland invites comparison to the medieval slouch, and indeed wants only the hennin and veil hanging from her head in order to be catapulted backwards in time some six hundred years. Students of posture could no doubt find a certain affinity between the medieval stance and that of the Twenties. It may well be, as I suspect,

that Mrs. Vreeland matriculated into that Great Gatsby era when ladies willed their bodies to look as much like cooked asparagus as possible, taking the form whatever sofa or chair they sat in. But whereas the posture of the Twenties could be unattractive, it looks good on Diana Vreeland.

Above her small-boned beautiful body, with its feet like the bound feet of Chinese ladies, Mrs. Vreeland's head sits independently on top of a narrow neck and smiles at you. Everything about her features is animated by amused interest: her nose, as broad as an Indian's, is boldly assertive; her eyes twinkle; her mouth emits the most amazingly aggressive and masculine laugh, a red laugh that is taken up by her cheeks, expertly rouged with an art which has gone out of style and of which she is one of the few remaining masters. Surrounding these features like a metallic skullcap is her navy-blue hair, which she wears lacquered back from her face. Diana Vreeland has, in fact, a fetish about hairlines and believes that, together with hands, they are the secret of elegance.

Mrs. Vreeland has an almost Chinese appearance, with her black tunics and plethora of gold jewelry, although Truman Capote said that her style is based on high-yellow chic. Combined with this compact, fresh-as-a-bandbox appearance and a walk like a rope unwinding, Diana Vreeland's personality is apt to prove a little startling to those who meet her for the first time. She bounces with a life that is utterly natural to her. Her resonant voice covers the gamut from an emphatic whisper to an equally emphatic and almost Rabelaisian roar. The total effect is almost Falstaffian, more remarkable precisely because it issues from a slim wisp of a body. Yet there is not the slightest trace of vulgarity in her positive, booming vivacity.

The terms of Mrs. Vreeland's human appeal are liberally peppered with an astonishing slang. One would think that she spent hours in ambiguous Times Square drugstores or Fifty-second Street night clubs, absorbing the highly coloured range of pimentoed expressions that are an integral part of her linguistic repertoire. Nor is her slang ever out of date. She will innovate expressions long before they have become popularly known. This gamey speech, combined with her personality, inevitably sends her friends off into gales of laughter at almost every sentence. [Diana Vreeland's linguistic repertoire and spontaneous, off-the-cuff aphorisms are now legendary. "Pink," she declared during a run-through, "is the navy blue of India." She always pronounced Celanese, the American synthetic fabric company, as if it were Italian: *chelahnayzay*. She returned corduroy to its original articulation, *cord du roi*. Her ubiquitous repetition of "pizazz"—a word she invented meaning flamboyance, daring, and the delight of the new and exciting—has now become part of the English language. Look it up!]

Although she is one of the most remarkable creatures who has lived and worked in the zany confines of the fashion world, a combination of Madame de Sévigné and Falstaff, Mrs. Vreeland graces that world with her presence, as unique a presence as it has ever boasted.

The astute narrator further elaborated in his valentine to her: "Mrs. Vreeland is more of a connoisseur of fashion than anyone I know...."

Whether supervising photography sittings, doing run-throughs in the office, or when reviewing clothes and accessories Mrs.

Vreeland was always cognizant of color. "I have an eye for color—perhaps the most exceptional gift I have," she declared. "Color depends entirely on the tonality. Red is the great clarifier—bright, cleansing and revealing. It makes all other colors beautiful. All my life I've pursued the perfect red."

While working with the eminent decorator Billy Baldwin on the redecoration of her apartment in the late fifties, Mrs. Vreeland suggested something neither of them had ever seen. "I want this room to be a garden—but a garden in hell," she said. The decorator instantly knew what she meant—red.

After a tireless search, Baldwin found the peerless print in the London shop of Colefax and Fowler, a scarlet chintz of bold Persian flowers. The decorator covered the whole room—walls, curtains, furniture, "the works"—with the fabric that achieved the "fire-and-brimstone" effect the editor had never seen before.

Bettina Ballard found Mrs. Vreelands's red garden room "one of the most attractive atmospheres that I know," comparing it to "an overcrowded Turkish seraglio on a rather elegant boat. Books, bibelots, calculated clutter, personal pictures [among them, sketches by Augustus John, Bébé Bérard, and Cecil Beaton of herself], and "treasures, many Scotch snuffboxes in horn and silver, are massed on tables, walls, and shelves looking as if one could never get around to seeing them all. A long-stemmed anemone stands in a long-stemmed vase. There are oriental divans against the wall covered with inviting cushions, and she dines at a table pushed against a divan with bright cushions propped behind her back. She presides on a big Indian print-covered sofa like a sultan's favorite, before and after dinner, with everyone gathered on small chairs at her feet. She lives in an atmosphere of informal luxury confined in crowded quarters, in an aura of intimacy and mystery."

Baldwin recounted in his autobiography that "Diana's apartment has since been described by Charles [de] Bestegui, that influential Parisian style setter, as 'the most complete dwelling in New York.' "

As Carmel Snow approached her seventieth birthday in 1957, she reluctantly retired from *Harper's Bazaar*. Her niece, Nancy White, the fashion editor at *Good Housekeeping*, inherited the position and the magazine where Mrs. Snow's standard of "top quality," her favorite expression, had been maintained for more than twenty-five years.

As much as Mrs. Vreeland was disappointed by not being picked as Mrs. Snow's replacement, she refused to be discouraged (she needed the job), and stayed on for five more years. "Elegance is refusal," is how she put it.

Throughout the late winter of 1962, rumors that Mrs. Vreeland was leaving *Bazaar* ran rife in the offices and corridors at 572 Madison Avenue. But leaving for where? Some of the staff speculated she would become a spokesperson for a major fabric manufacturer; others prophesied a political appointment in the new Kennedy administration. It was almost a letdown when *The New York Times* announced that March that "Mrs. Vreeland, starting in mid-April, would work with the staff on all aspects of the magazine," the "other" magazine—*Vogue!* ■

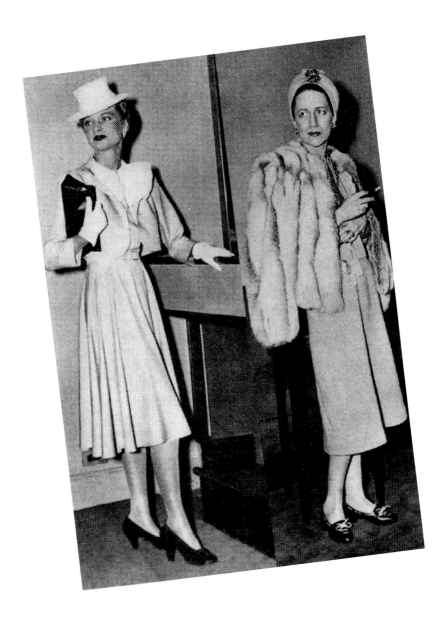

For the Fashion Group's luncheon at the Biltmore Hotel on March 7, 1939, eight fashion personalities were selected to design costumes "that they themselves would wear that summer." "Mrs. T. Reed Vreeland of *Harper's Bazaar*," chose as her costume a beige shantung one-piece dress with a "high-crowned white sailor," for "that summer neat and scrubbed look." Mrs. Vreeland (right) appears here with the model who wore her creation. PHOTOGRAPH: courtesy the Fashion Group.

Harper's BAZAAR

January 1942

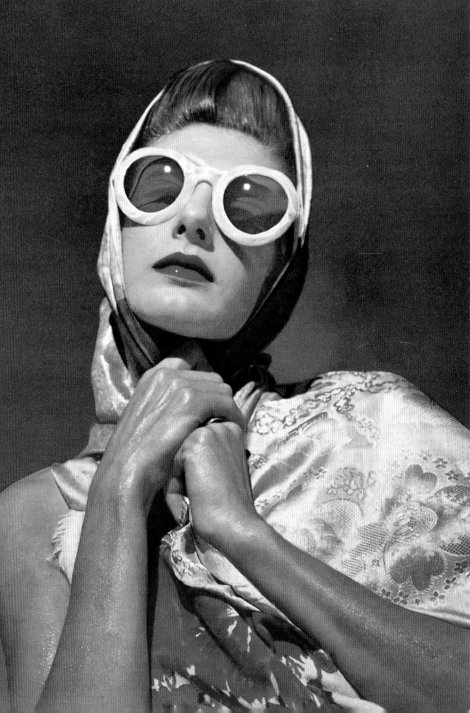

TRAVEL FASHIONS

0 cents · 60 cents in Canada · 2/6 in London

Mrs. Vreeland on location...

In October 1941, Diana Vreeland traveled to Arizona with photographer Louise Dahl-Wolfe to photograph resort clothes for the January 1942 issue of *Bazaar*. ABOVE: Mrs. Vreeland working on location with model Bijou Barrington. PHOTO-GRAPH: courtesy Staley/Wise Gallery. OPPOSITE: The January 1942 cover of the magazine. COVER: the Hearst Corporation; final engraver's proof, courtesy the Museum at the Fashion Institute of Technology, gift of Louise Dahl-Wolfe.

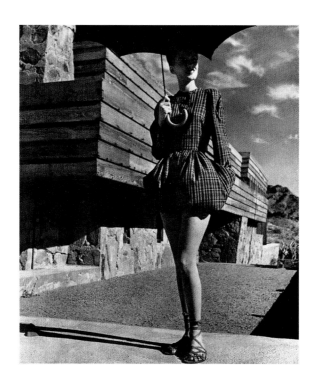

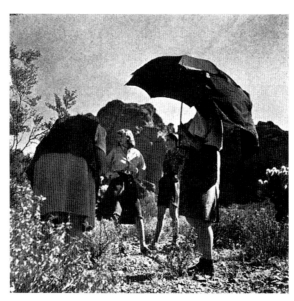

ABOVE: Model Bijou Barrington posed on the terrace of Shiprock, a house designed by Frank Lloyd Wright in 1938 near Phoenix, Arizona. BELOW: Mrs. Vreeland snapped photographer Louise Dahl-Wolfe with her assistant, Hazel Kingsbury, along with models Wanda Delafield (right) and Bijou Barrington, during a shoot near Phoenix for the January 1942 issue of *Bazaar*. OPPOSITE: Wanda Delafield on the terrace at Shiprock. PHOTOGRAPHS: courtesy Staley/Wise Gallery.

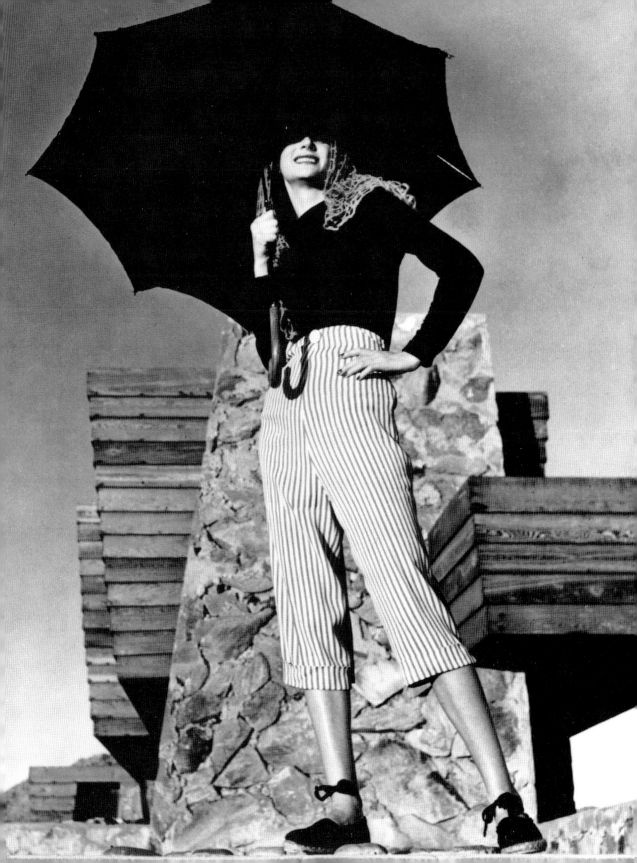

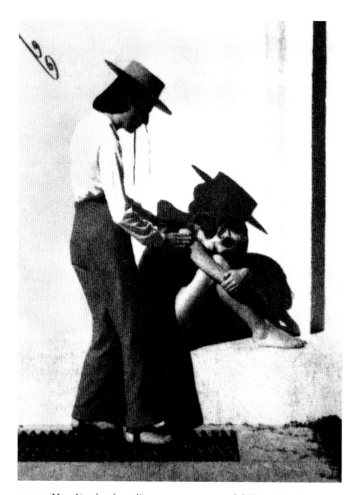

ABOVE: Mrs. Vreeland applies sunscreen to model Bijou Barrington on location near Phoenix, Arizona, with photographer Louise Dahl-Wolfe. PHOTOGRAPH: courtesy Staley/Wise Gallery. OPPOSITE: When Wanda Delafield succumbed to the sun while posing at Shiprock, the editor stepped in to model a pair of "cigar-brown slacks" for the January 1942 issue of *Bazaar*. PHOTOGRAPH: final engraver's proof, courtesy the Museum at the Fashion Institute of Technology, gift of Louise Dahl-Wolfe.

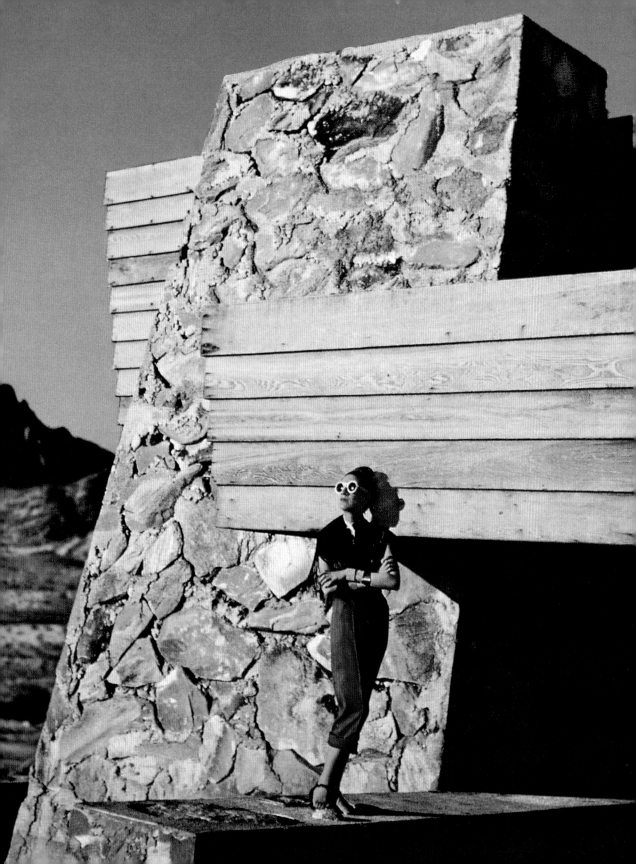

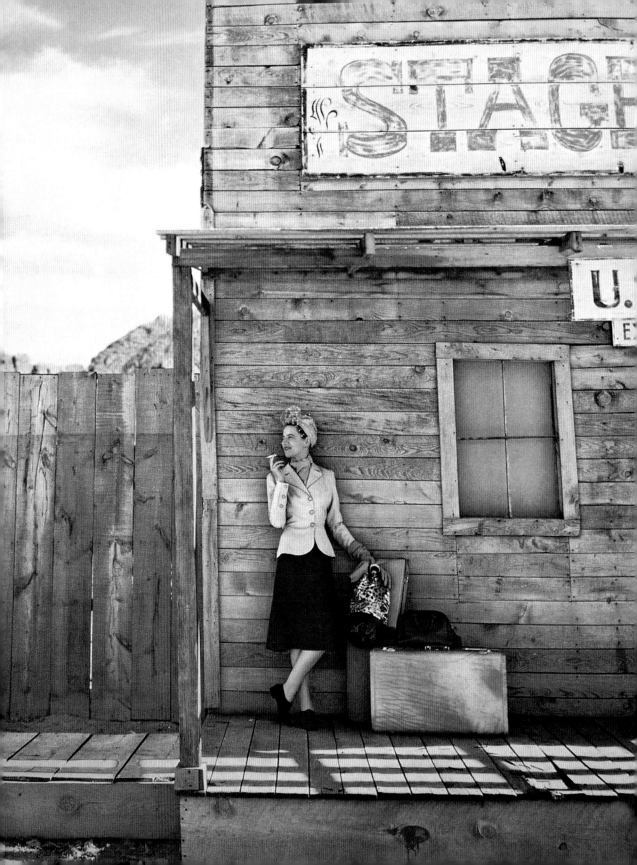

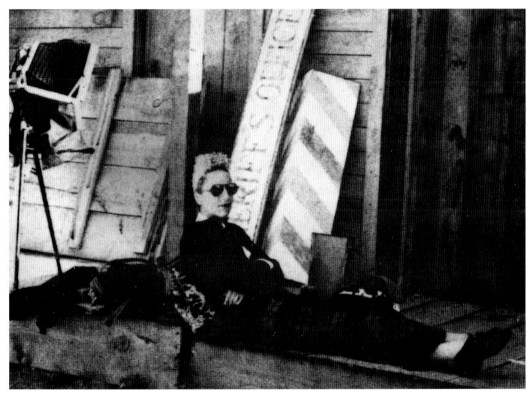

OPPOSITE: The fashion editor substitutes as model for the January 1942 issue of *Bazaar*. Louise Dahl-Wolfe photographed Mrs. Vreeland wearing "the perfect outfit for traveling in a hot climate, cool fresh, right in the turmoil of a big city station or at Godforsaken junction where transcontinental luxury trains drop ranch-bound passengers." PHOTOGRAPH: final engraver's proof, courtesy the Museum at the Fashion Institute of Technology, gift of Louise Dahl-Wolfe. ABOVE: Mrs. Vreeland resting in a deserted movie set while on a shoot near Phoenix, Arizona. PHOTOGRAPH: courtesy Staley/Wise Gallery.

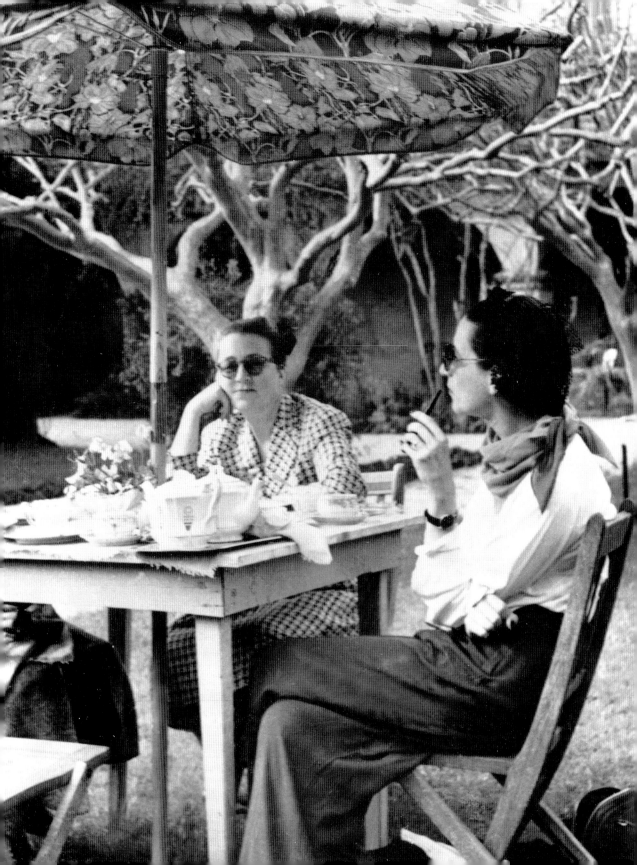

OPPOSITE: Louise Dahl-Wolfe and Mrs. Vreeland take time out for an *alfresco* luncheon while working on location (early 1940s). PHOTOGRAPH: courtesy Staley/Wise Gallery. ABOVE: drawing of Mrs. Vreeland by artist Christian Bérard. DRAWING: The Hearst Corporation.

I loathe

narcissism, but

I approve

of vanity.

—Mrs. Vreeland, in ALLURE

WHY DON'T YOU ... ?

Mrs. Vreeland's Christmas gift suggestions, December 1936.

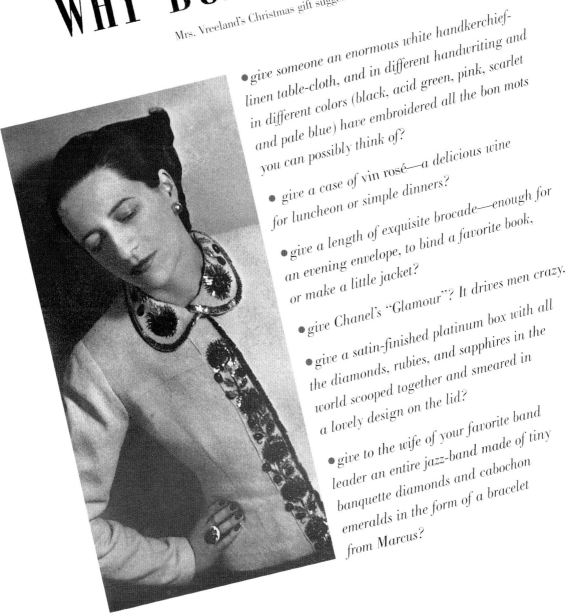

- give someone an enormous white handkerchief-linen table-cloth, and in different handwriting and in different colors (black, acid green, pink, scarlet and pale blue) have embroidered all the bon mots you can possibly think of?

- give a case of vin rosé—a delicious wine for luncheon or simple dinners?

- give a length of exquisite brocade—enough for an evening envelope, to bind a favorite book, or make a little jacket?

- give Chanel's "Glamour"? It drives men crazy.

- give a satin-finished platinum box with all the diamonds, rubies, and sapphires in the world scooped together and smeared in a lovely design on the lid?

- give to the wife of your favorite band leader an entire jazz-band made of tiny banquette diamonds and cabochon emeralds in the form of a bracelet from Marcus?

While working with a new photographer, Louise Dahl-Wolfe, Diana Vreeland posed in a "bright parlor pink jacket embroidered in gold foil and ruby red stones *à la* Schiaparelli" which appeared in the April 1937 issue of *Bazaar*. Dahl-Wolfe was the first woman to photograph fashion for the magazine. PHOTOGRAPH: courtesy Staley/Wise Gallery.

WHY DON'T YOU ... ?

Mrs. Vreeland's elementary suggestions for practical dressing.

●*fit your clothes easily? Only [the] English and Americans have this mania for snappy tightness.*

●*try a beige linen blouse and black linen shorts on the beach with red zippers and a tiny monogram just below the belt?*

●*when you are buying black in any material, see that it is very, very black?*

●*have a bed-saque with a hood to pull up over your combs and curlers?*

●*have two pairs of day shoes exactly alike, except that one pair has thin rubber soles for damp days? Any cobbler can put these on.*

●*wear violet velvet mittens with everything?*

●*stick a pearl scarf-pin in your scarf?*

by Diana Vreeland

Taking advantage of the natural light in Carmel Snow's high-ceilinged living room in the Ritz Tower, Louise Dahl-Wolfe photographed the young model Betty Bacall for the March 1943 issue of *Bazaar*. PHOTOGRAPH: final engraver's proof, courtesy the Museum at the Fashion Institute of Technology, gift of Louise Dahl-Wolfe.

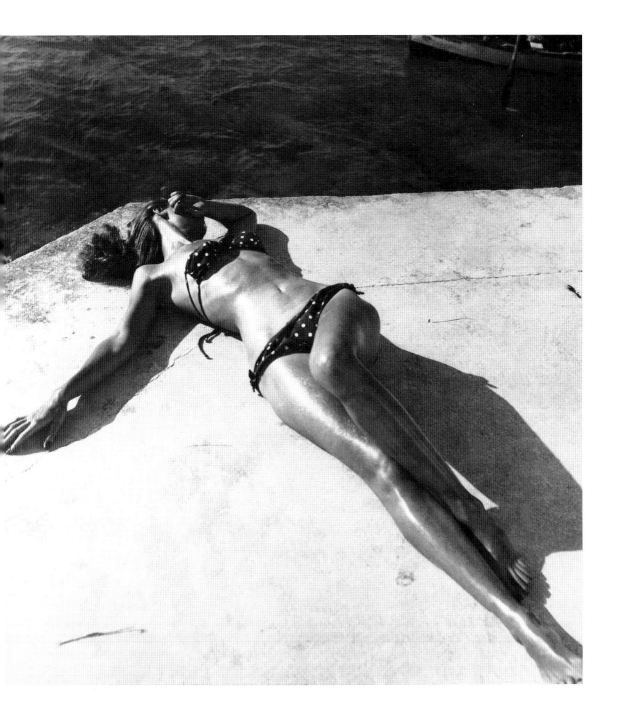

why don't you?

by Diana Vreeland

What to wear "for week-ends in the country or small dinners in your own home…," November 1937.

- *wear black paillette slacks with a hand-pleated white handkerchief linen blouse, black lacquer Chanel bracelets on each wrist and a huge multicolored jeweled pin at the throat?*

- *find one dress that you like and have it copied many times? You will be much more successful than if you try to produce new effects each evening.*

- *for rainy days and fishing, wear gray or navy flannel slacks, cut short, a heavy gray wool cardigan buttoned to the neck with silver buttons, and patch pockets of brilliant yellow with acid-green piping?*

- *to get away from the démondé look of all-black in the daytime, try a hat of cherry pink, mauve, and gray tweed with your black dress?*

- *wear black* breitschwantz *mules with red leather heels?*

Soon after spotting the bikini on the French Riviera in 1946, Mrs. Vreeland had American sportswear designer Carolyn Schnurer copy the suit in green-and-white Mallinson rayon. Toni Frissell photographed the bikini at Montego Bay, Jamaica. The photograph, which appeared in the May 1947 issue of *Bazaar*, was the first picture of a bikini to be published in an American magazine. PHOTOGRAPH: courtesy Staley/Wise Gallery.

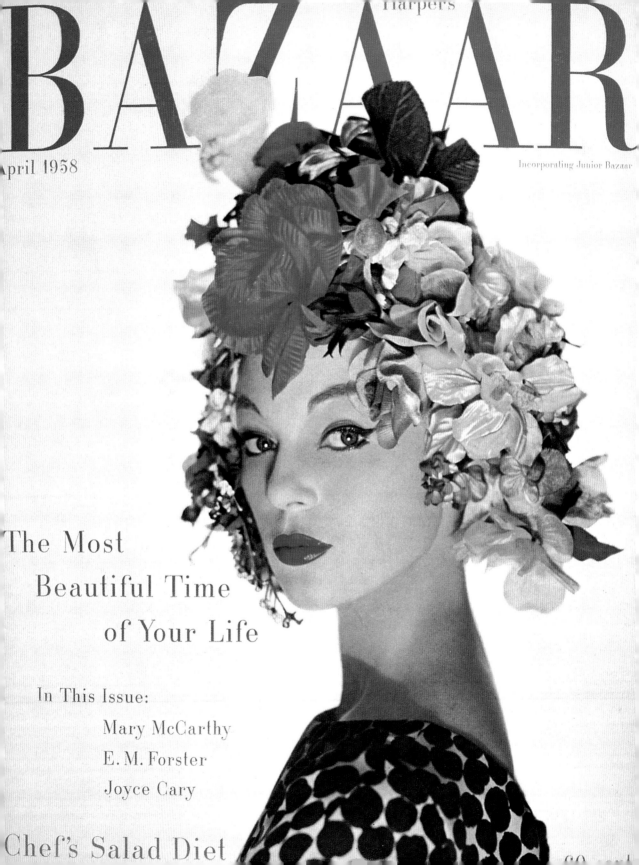

Harper's

BAZAAR

April 1958

Incorporating Junior Bazaar

The Most
Beautiful Time
of Your Life

In This Issue:

Mary McCarthy

E. M. Forster

Joyce Cary

Chef's Salad Diet

OPPOSITE: Louise Dahl-Wolfe recalled how, during a sitting in her studio, Diana Vreeland created a flowery wig by pinning French silk flowers on model Ivy Nicholson's head, which was then photographed for the April 1958 cover of *Bazaar* magazine. The "flower-massed cap" was credited to Adolfo of Emme. COVER: The Hearst Corporation; final engraver's proof, courtesy the Museum at the Fashion Institute of Technology, gift of Louise Dahl-Wolfe. ABOVE: In October 1941, Dahl-Wolfe snapped Mrs. Vreeland sporting a striking scarlet sombrero she donned while they were on location in the Southwest to photograph resort clothes. PHOTOGRAPH: courtesy Staley/Wise Gallery.

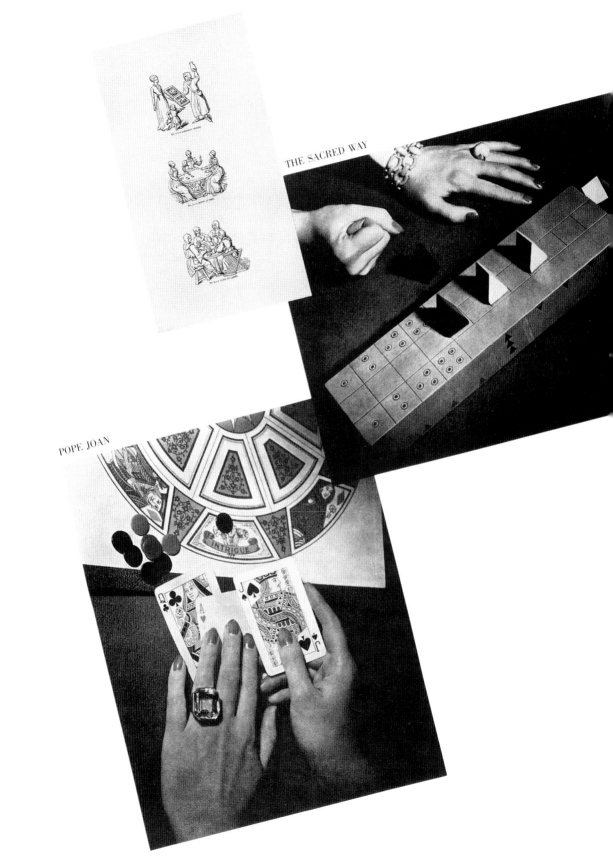

THE SACRED WAY

POPE JOAN

by Diana Vreeland

WHY DON'T YOU ... ?

Ways to travel in style, walk stylish dogs, and other disparate advice.

●*have an elk-hide trunk for the back of your car?*
Hermès of Paris will make this.

●*have a dark blue car upholstered in dark blue serge*
with robe and cushions in the same material, monogrammed and taped around
like a horse blanket in bright red? A very smart Italian does this.

●*travel with a little raspberry-colored cashmere blanket*
to throw over yourself in hotels and trains?

●*be completely comfortable and warm by the fire after skiing*
in wine red felt boots with soles and sides of pale blue kid?

●*put all your dogs in bright yellow collars and leads*
like all the dogs in Paris?

●*have your cigarettes stamped with a personal insignia*
as a well known explorer did with [a] penguin?

Mrs. Vreeland's beautiful hands appeared in Louise Dahl-Wolfe's photographs illustrating two ancient board games for the July 1937 issue of *Bazaar*. The Sacred Way, a game played in Egypt in 1563 B.C. Pope Joan, an Elizabethan game. PHOTOGRAPHS: courtesy Staley/Wise Gallery.

Why Don't You...?

Glittering advice for readers about an important fashion accessory: jewels.

•wear, like the Duchess of Kent, three enormous diamond stars arranged in your hair in front?

•remember that long swinging diamond chandelier earrings are frightfully smart again, and wear them occasionally as Madame Sert does, pinned four inches below either shoulder on a high-necked black satin dress?

•consider the chic of wearing bracelets high on the arm and try Lady Mendl's thick black leather bracelets, which she wears just above the elbow with a huge diamond bracelet at the wrist?

•have the most beautiful necklaces in the world made of huge pink spiky coral with big Siberian emeralds?

•try the lovely combination of tourmalines and pale rubies?

OPPOSITE: Jewelry designer Kenneth Jay Lane remarked that "she brings the eye of a connoisseur, the imagination of a poet, and the confidence of a grenadier to bear on the whole concept of jewelry." PHOTOGRAPH: George Hoyningen-Huene early 1940s, courtesy Staley/Wise Gallery.

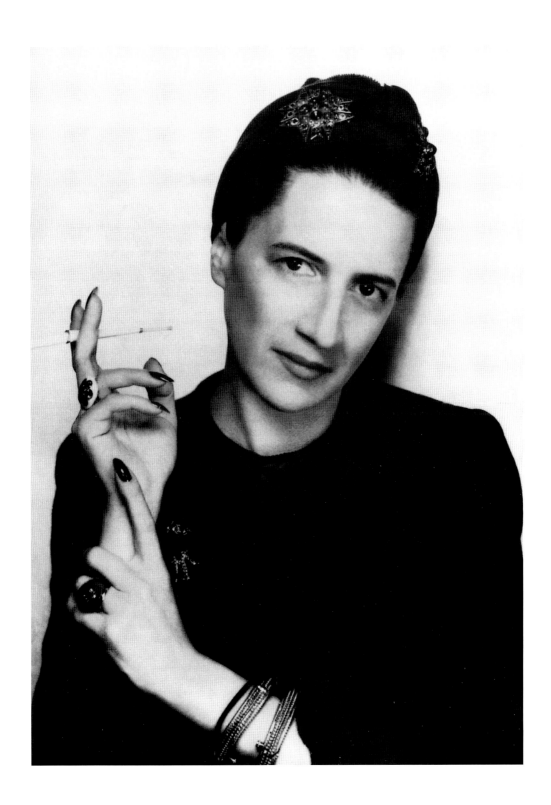

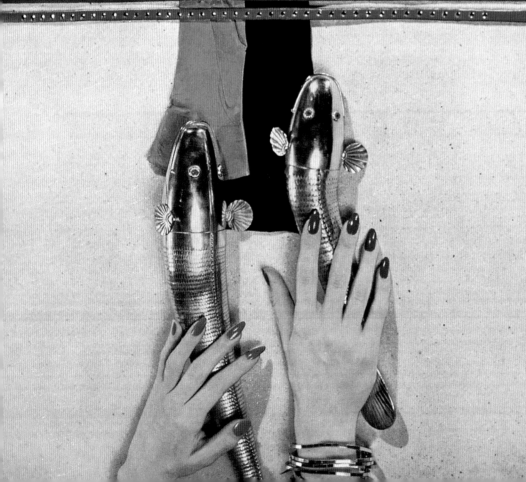

Admonishments on what to wear and, sometimes,
the special occasion on which to wear it.

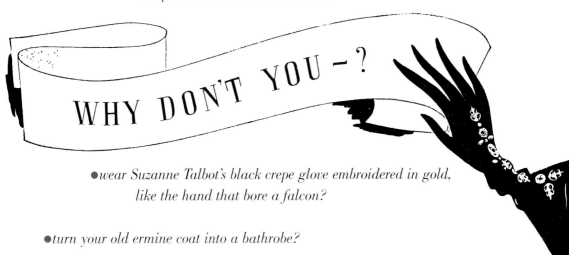

WHY DON'T YOU — ?

●*wear Suzanne Talbot's black crepe glove embroidered in gold,*
like the hand that bore a falcon?

●*turn your old ermine coat into a bathrobe?*

●*if you are a tawny blond, wear*
bright yellow pajamas with carved coral bracelets?

●*knit yourself a little skullcap?*

●*order Schiaparelli's cellophane belt with your name and telephone number on it?*

●*wear loose velvet gloves in wonderful colors—the right hand*
in violet velvet, the left in burgundy? These gloves at the theatre
emerging from a beautiful fur cape would be very effective.

●*sweep into the drawing-room on your first big night*
with an enormous red-fox muff with many skins?

●*go to the theatre in a black tweed evening suit with a*
jacket embroidered in brilliant paillettes?

Louise Dahl-Wolfe arranged a subtle palette of spring accessories in which she included Mrs. Vreeland's "well-dressed hands" holding part of her collection of Indian brass articulated fish. The photograph appeared in the March 1951 issue of *Bazaar*. PHOTOGRAPH: final engraver's proof, courtesy the Museum at the Fashion Institute of Technology, gift of Louise Dahl-Wolfe.

ABOVE: Model Lisa Fonssagrives posed on the set in the photographer Louise Dahl-Wolfe's 57th Street studio as Mrs. Vreeland arranged the satin ball gown by Hattie Carnegie. OPPOSITE: Dahl-Wolfe photographed Lisa for the September 1945 issue of *Bazaar* wearing Hattie Carnegie's "sugar-loaf" hat designed "for a profile as proudly bare as Nephritite's." PHOTOGRAPHS: courtesy Staley/Wise Gallery.

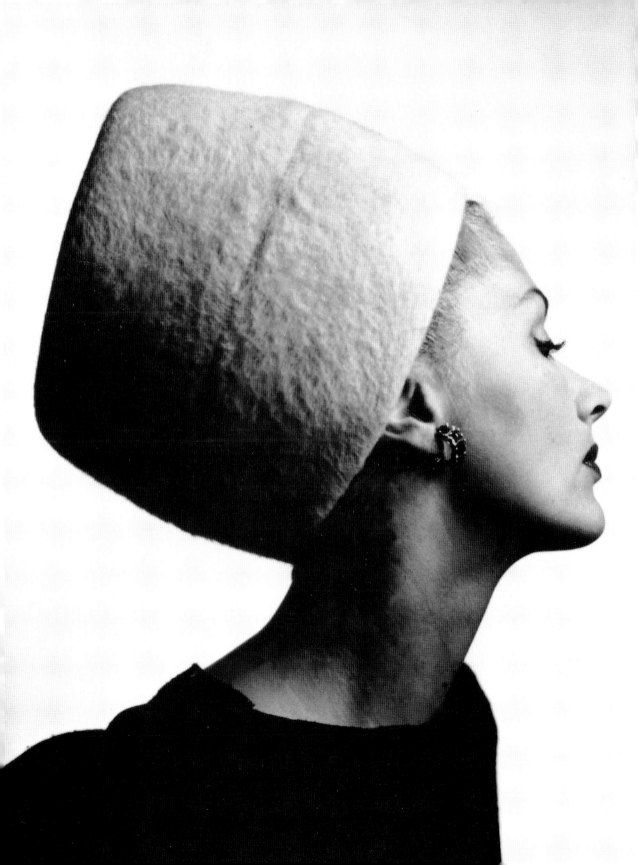

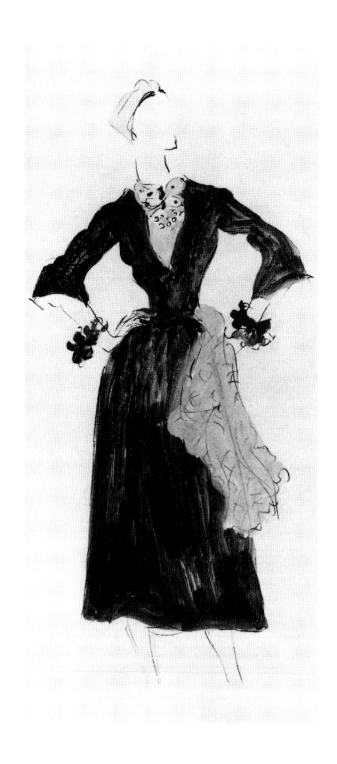

by Diana Vreeland

WHY DON'T YOU . . . ?

Mrs. Vreeland advocated both spectacular jewels or frankly fake ones.

•*wear a blue sapphire thistle in one ear and a ruby thistle in the other?*

•*appear with all the jewels on your left side, diamonds set in platinum…on your right side, duplications of these ornaments only without the diamonds and in plain gold?*

•*wear yellow diamond flowers in your ears, a flower clipped to the lobe of one ear, another flower clipped to the top of the other?*

•*take your old childhood coral beads and have them done up into big pins of flower designs on bracelets, studding the hole the cord went through with gold or a tiny diamond? Seaman Schepps does this beautifully.*

•*spear your tweeds with a Scotch kilt pin of mauve, green and pink stones, put together in gold?*

•*tie black tulle bows on your wrists?*

With her wrists tied with black tulle bows and her signature turban in place, Mrs. Vreeland posed for artist Marcel Vertés wearing "a fireside dress in watermelon-pink." The drawing appeared in the December 1940 issue of *Bazaar*. DRAWING: courtesy the Hearst Corporation.

OPPOSITE: For the April 1945 issue of *Bazaar*, Louise Dahl-Wolfe photographed Lauren Bacall wearing an "evening sweater" with elbow-length gloves. Dahl-Wolfe's assistant, Otto Fenn, painted the background for the photograph. ABOVE: Dahl-Wolfe painting backgrounds of Chinese calligraphy in her 57th Street studio. PHOTOGRAPHS: courtesy Staley/Wise Gallery.

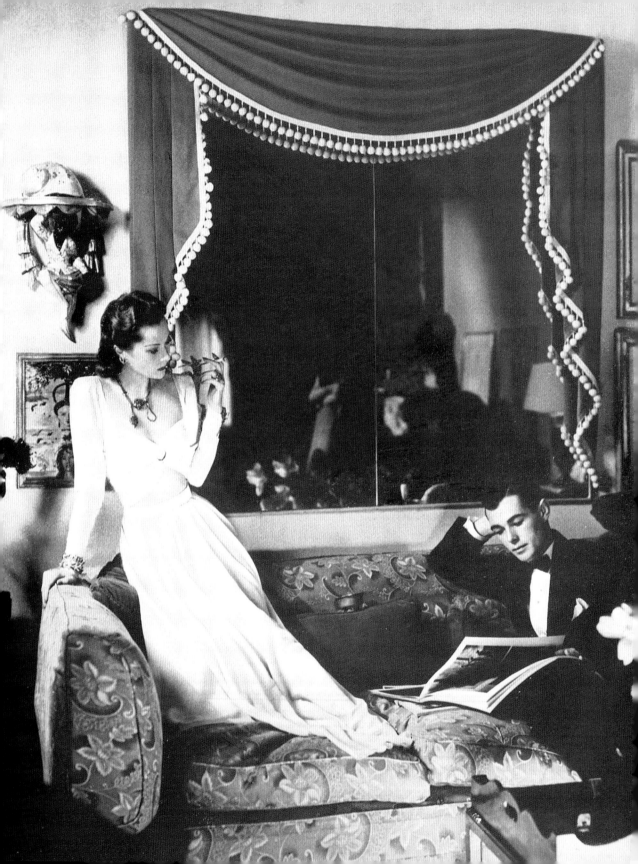

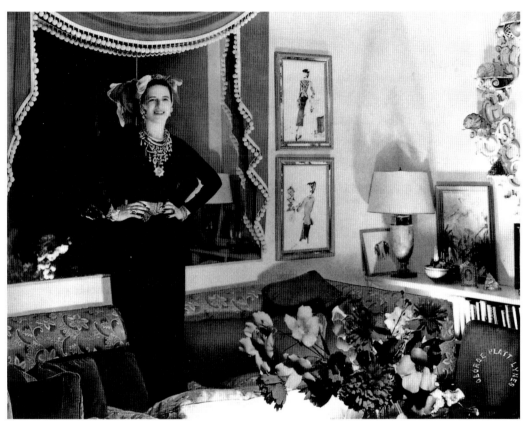

ABOVE: George Platt Lynes photographed Diana Vreeland in her Park Avenue apartment surrounded by her books, bibelots, and calculated clutter. PHOTOGRAPH: courtesy the estate of George Platt Lynes. OPPOSITE: For the March 1940 issue of *Bazaar*, George Hoyningen-Huene photographed an evening dress of "white silk crepe, draped and cut away with consummate skill" in the fashion editor's apartment. PHOTOGRAPH: courtesy Staley/Wise Gallery.

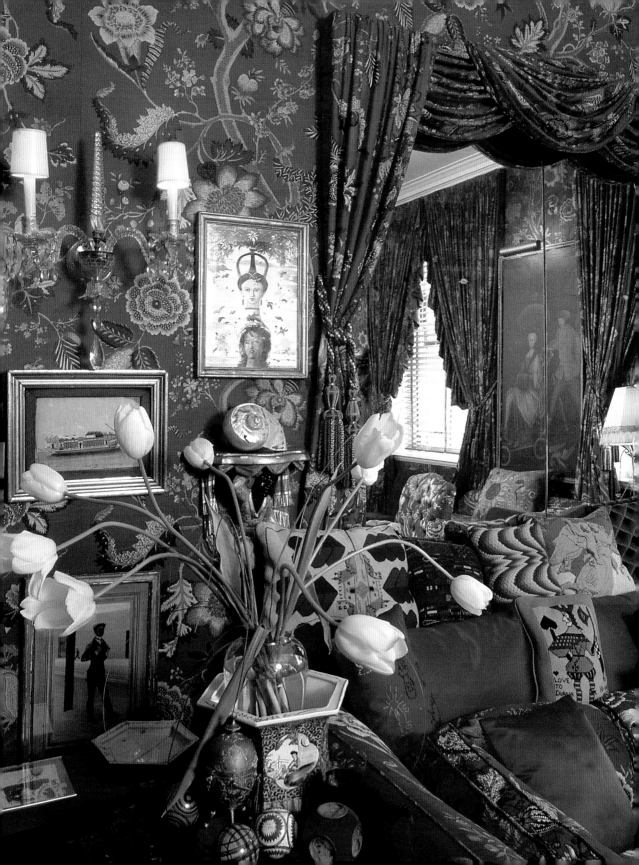

Why Don't You…?

Some decorating advice for creating a more fashionable home.

•*have your bed made in China—the most beautiful
bed imaginable, the head board and spread of yellow satin embroidered
in butterflies alighting and flying, in every size and in exquisite colors?*

•*pick up in Florida the prettiest shells you can find and make
them into a mirror frame of a baroque scroll design?*

•*bring back from Central Europe a huge white Baroque
porcelain stove to stand in your front hall, reflected in the parquet?*

•*if you have a greenhouse, raise Japanese cherry trees
or white lilac trees and put them around your bed
against brown Coromandel screens?*

•*have a white monkey-fur bedcover mounted on yellow velvet?*

Diana Vreeland redecorated her Park Avenue living room with the assistance of the eminent decorator Billy Baldwin.
"I want this room to be a garden—but a garden in hell!" she told him. Using a scarlet chintz of bold Persian flow-
ers that he found in London, Baldwin covered the whole room—walls, curtains, furniture, "the works"—achiev-
ing Mrs. Vreeland's desired "fire-and-brimstone" effect. Lizzie Himmel photographed the apartment shortly before
it was dismantled in 1990. PHOTOGRAPH: courtesy Lizzie Himmel.

WHY DON'T YOU ...?

Sharing hints with *Bazaar* readers for entertaining fashionably.

- have boxes copied after Russian Easter eggs in dull enamel and jewels to keep on your afterdinner coffee tray for saccharine for all those who do not take sugar?

- serve individual Pfirsch Bowle which is a peeled peach in a chilled glass with ice-cold Moselle or Rhine wine poured in? Marvelous at tea time.

- use Battersea enamel saltcellars as ashtrays?

- at a supper party, have each little table covered with round, floor-length table-cloths? Each cloth of three separate colors— Dresden blue, pink and yellow, each flounced like a petticoat and each table quite a different combination of colors, with contrasting colored candles in high gilt candle-holders.

- remember how delicious champagne cocktails are after tennis or golf? Indifferent champagne can be used for these.

- use a gigantic shell instead of a bucket to ice your champagne?

- shop at Woolworth's for little Scotch plaid sock arrangements called Hi-Jacks made to slip on your cold drink glasses to keep the table from spotting?

by Diana Vreeland

An eighteenth-century painted leather screen divided a portion of Mrs. Vreeland's crowded living room in her Park Avenue apartment. Billy Baldwin observed that the apartment was "the most definitive personal statement" that he had ever seen in all his years of decorating. PHOTOGRAPH: courtesy Lizzie Himmel.

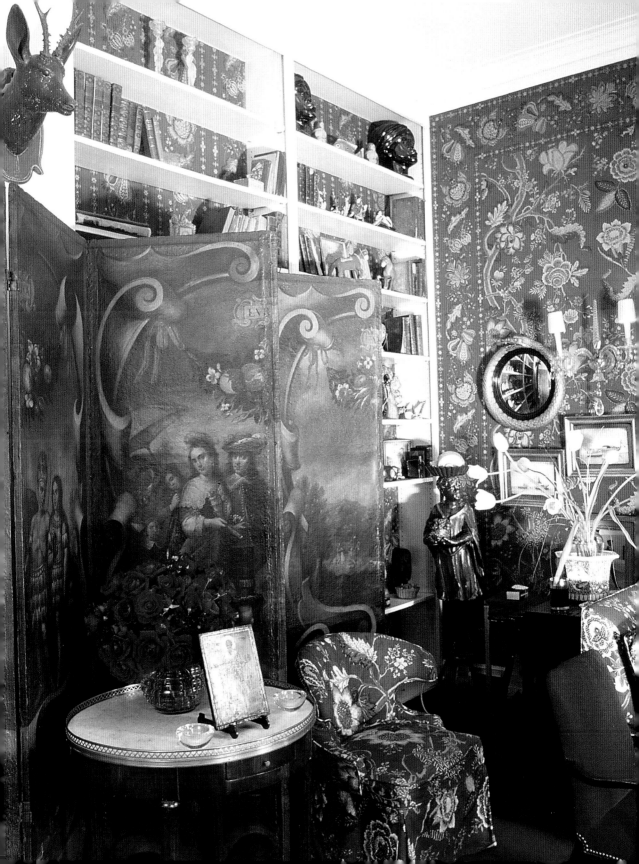

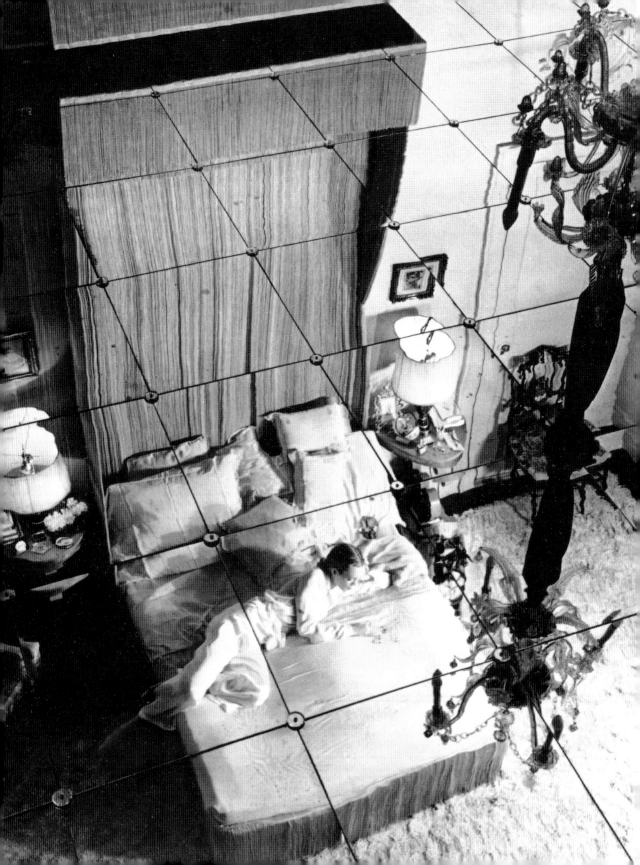

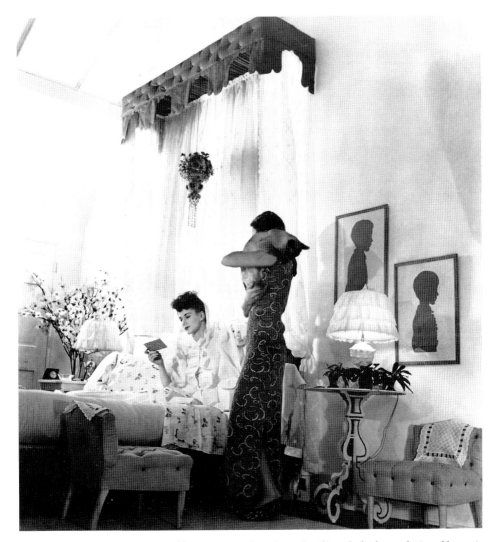

OPPOSITE: Louise Dahl-Wolfe aimed her camera at the mirrored ceiling of a bedroom designed by society decorator George Stacey when she photographed Lizzie Gibbons wearing white silk pajamas for the April 1941 issue of *Bazaar*. ABOVE: Mrs. Vreeland styling a model wearing a hooded bed-jacket in her own bedroom in her weekend house in Brewster, New York. On the wall are framed silhouettes of her two sons. PHOTOGRAPHS: courtesy Staley/Wise Gallery.

by Diana Vreeland

WHY DON'T YOU … ?

More decorating suggestions for a more fashionable home life: some more, some less, practical.

● *have a row of white pots on your window-sill with orange and brown nasturtiums trained into pyramids around little cone-shaped trellises?*

● *if you have a large studio room, why don't you put an enormous, deep sofa at one end? Over this drape high on the wall a tremendous canopy of yards and yards of material— copying your whole effect from the theatrical tapestries of Venice?*

● *trim the beige quilted satin petticoat of a dressing-table with two wide flounces of black lace, mounted with big flat jet beads?*

● *go to Dazian, the theatrical-material shop, and get fake leopard skin for your bathroom floor and fake beige fur for your slipper chair?*

● *have a yellow satin bed entirely quilted in butterflies?*

● *revive the old-fashioned hat tree—this time a white lacquer pole topped with ostrich feathers of carved wood, or a black and gold palm tree— most useful in a bathroom to hold your clothes?*

Lining the top of the bedroom fireplace in her apartment was Mrs. Vreeland's collection of antique painted *papier-mâché* wig stands. An early nineteenth-century English portrait of aristocratic children surveys from above. PHOTOGRAPH: courtesy Lizzie Himmel.

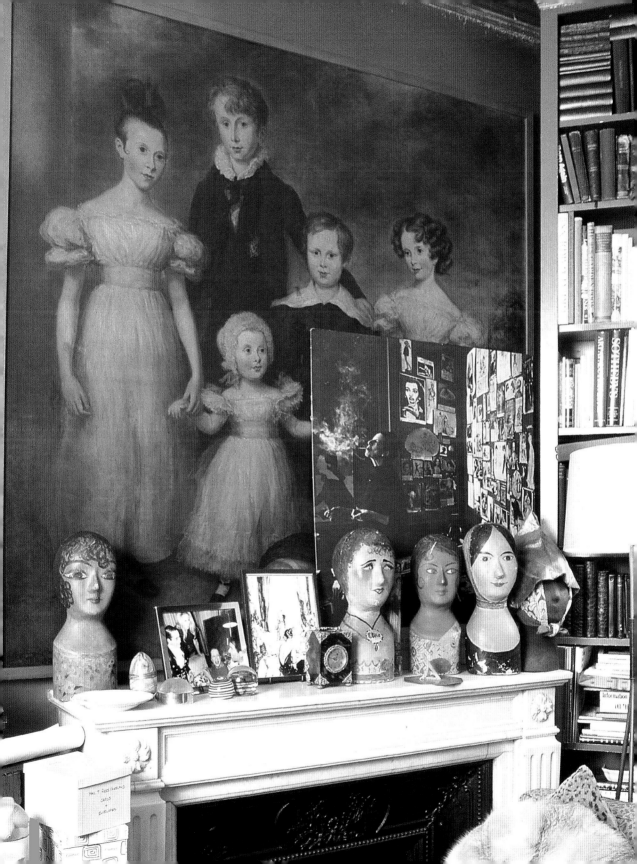

why don't

●*rinse your blond child's hair in dead champagne
to keep its gold, as they do in France?*

●*hide your little girl's lanky limbs in Chinese cotton
pants and little Chinese cotton coats?*
They're sweet for supper at home.

●*remember that children always look better before they have their hair cut
and the day before you let down their clothes?*
(Don't swamp them in loose clothes and don't remove all their hair.)

●*remember that little girls of eleven to thirteen look
divine in full dresses of black taffeta with crimson sashes,
white silk socks and Kate Greenaway slippers of crimson satin?*

●*remember little girls and boys look divine in tiny green
felt Tyrolian hats?—the smaller the child, the longer the feather.*

you ★ —

Advice for raising fashionable children, August 1937.

●*if you can do* point de Turque,
make your baby a top sheet and pillow-slip
encrusted with myriad stars of all sizes?

●*put them in Loden coats like the little Tyrolian cowherds,*
and in high white-knitted Tyrolian socks?

●*turn your child into an Infanta for a fancy-dress party?*

●*photograph [your child] sitting against the mirror?*
The full reflection is adorable.

●*cut your little girl's hair with a bang and*
tie it with a black velvet ribbon?

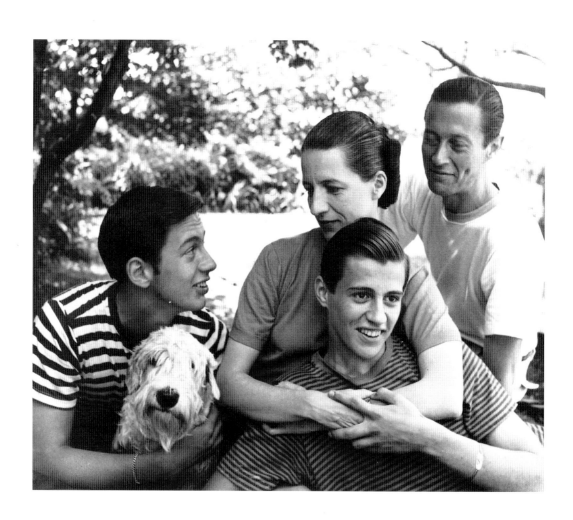

by Diana Vreeland

WHY DON'T YOU ... ?

Some recommendations for raising children (reflecting experiences bringing up her sons).

•*remember that little black-eyed boys look divine
in bright purple tweed coats and velvet collars?*

•*paint a map of the world on all four walls of your
boys' nursery so they won't grow up with a provincial point of view?*

•*design monograms with circles around them for the pockets of your
children's cardigans and the sleeves of their dressing-gowns?*

•*build in a bunk like Shirley Temple's in* Captain January,
with drawers underneath for clothes and toys?

•*tie an enormous bunch of silver balloons on
the foot of your child's bed on Christmas Eve?*

Louise Dahl-Wolfe photographed Mrs. Vreeland with her husband Reed and sons Frecky and Timmy during a visit to the Creamery, her home near Flemington, New Jersey. PHOTOGRAPH: courtesy Staley/Wise Gallery.

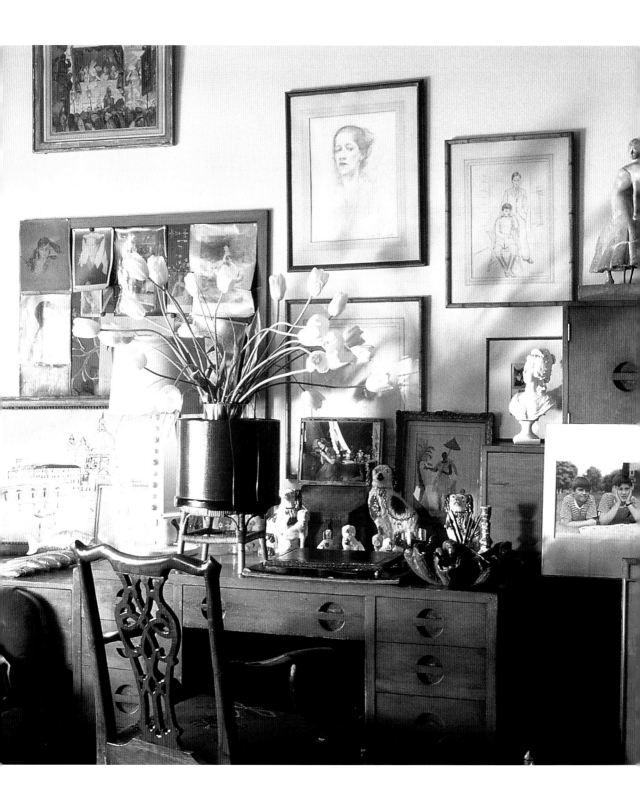

by Diana Vreeland

WHY DON'T YOU . . . ?

Some ideas for home decorating.

●*start a topiary garden of box or yew, and*
clip the bushes into peacocks and poodles? They stay green all winter
and brought inside in tubs look lovely in a formal hall.

●*whitewash a pair of old linen-closet steps and*
use on a porch with finger-bowls and jars full of flowers
or as a child's bedside table for lamp, book, and pencils?

●*cover a big cork bulletin board in bright pink felt,*
banded with bamboo, and pin with colored thumb-tacks all your various
enthusiasms as your life varies from week to week?

●*have your telephone-message pads, scratch pads, and menu cards all*
the same, such as white with red printing and initials or blue with navy blue?

●*do your closet shelves in immaculate white organdy, pleated,*
with Lubin's scented pink flannels wrapped around your things?

●*have a private staircase from your bedroom to the library*
with a needlework carpet with notes of music worked on each step—
the whole spelling your favorite tune?

Drawings, postcards, photographs, and an assortment of English Staffordshire dogs surrounded Mrs. Vreeland's desk of stackable cabinets made for her in the 1930s, which filled one wall of her Park Avenue living room. A photograph by Louise Dahl-Wolfe of Mrs. Vreeland's sons is propped on the right. PHOTOGRAPH: courtesy Lizzie Himmel.

WHY DON'T YOU...?

Color innovations for the home.

•*paint every door in a completely white house the color
of a different flower—and thereby give each room its name?*

•*if you have a dark dining-room in a city apartment,
stop trying to brighten it and paint it dark grape red
and drape the windows in festoons of real Scotch tartan?*

•*have a room done up in every color green? This will
take months, years, to collect, but it will be delightful—
a mélange of plants, green glass, green porcelains,
and furniture covered in sad greens, gay greens, clear,
faded, and poison greens?*

•*if you have a shining parquet floor, have potted cinerarias
of every color of blue banked around the sofa
at one end of the room?*

•*realize, realize the return of black, and black and white,
in decoration? It is of tremendous importance.
Use it whenever you can.*

An overflow of personal treasures filled bookshelves on a wall in Mrs. Vreeland's living room. Behind one of the gilt metal-mounted drinking horns she placed her portrait by Cecil Beaton; another portrait (bottom, center) was done by her friend Christian Bérard. PHOTOGRAPH: courtesy Lizzie Himmel.

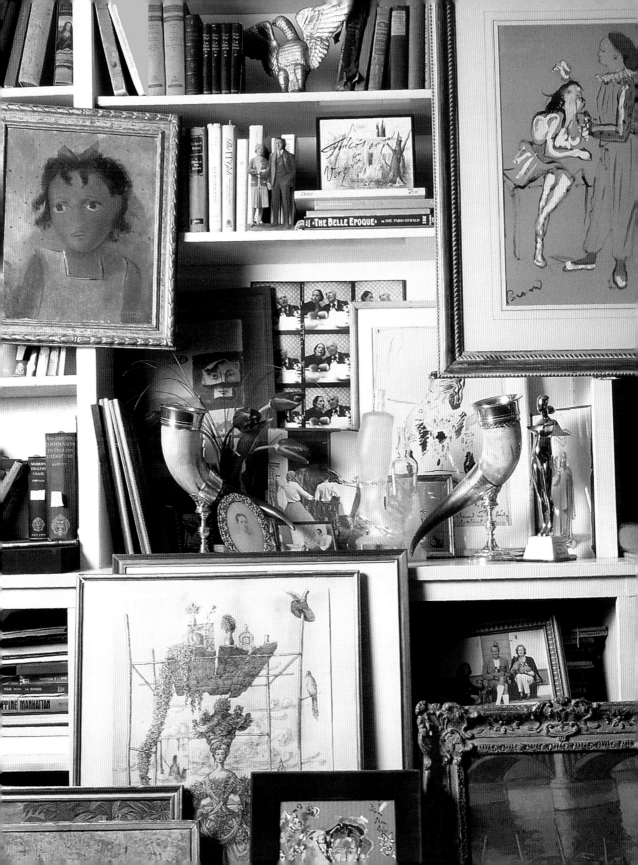

ENDNOTE

The photographs reproduced in this book are cropped as closely as they originally appeared in *Bazaar* magazine. In laying out the pages containing Mrs. Vreeland's "Why Don't You…?" columns, I duplicated or adapted Alexey Brodovitch's graphic design. I am indebted to the Museum of the Fashion Institute of Technology for allowing me to reproduce the final engraver's proofs of the covers and four-color photographs that Louise Dahl-Wolfe bequeathed to its archives. The color of the final proofs is the result of Dahl-Wolfe's close collaboration with the engraver of her *Bazaar* photographs. To keep the tone of the period of the magazine, I have in many instances used at least part of the caption describing the clothes or accessories depicted in the photographs. In the text I have generously excerpted the firsthand observations and perceptions of Bettina Ballard and Cecil Beaton of Mrs. Vreeland at work, at home, and of her amazing personality and appearance. ■

Performance is all
I cared about as a child
and it's all I care about now.
I don't go to see a play
to see a great play,
I go to see a great interpretation.
Everything is interpretation.

—ALLURE

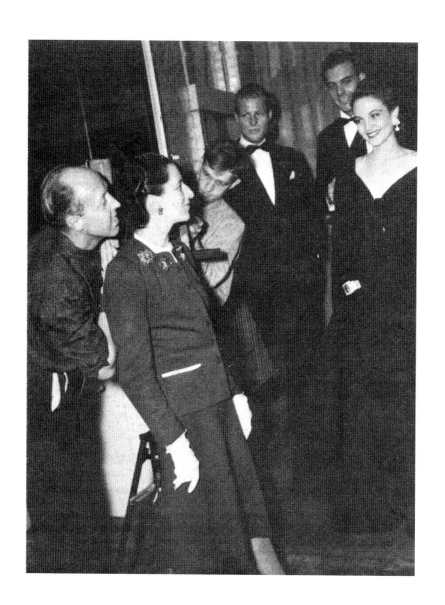

ACKNOWLEDGMENTS

Diana Vreeland emphatically explained in her autobiography that she never worried about "a fact, a cause, an atmosphere. It was me—projecting to the public. That was my job. I always had a perfectly clear view of what was *possible* for the public. GIVE 'EM WHAT THEY NEVER KNEW THEY WANTED." And she did. It was for her public, her people, that for so many years she edited fashion magazines and offered advice to make it "possible" to lead a more fashionable life.

In compiling, collecting, and collocating the material of Mrs. Vreeland's years with *Bazaar* magazine, literally dozens of people have contributed in many ways—some with memories and reflections, others with interest and enthusiasm, and still others with kindness, patience, and precious time. Therefore, I would like to acknowledge with sincere appreciation the following people and institutions:

Katherine Betts, editor-in-chief of *Harper's Bazaar*, for her interest and enthusiastic support for this book, and the Hearst Corporation who granted the rights to reproduce the photographs, sketches, and samplings from Mrs. Vreeland's "Why Don't You…?" columns. Other members of the Hearst Corporation who contributed greatly are: Jeanette Chang, international publishing director, and Dawn Roode, managing editor at *Bazaar*.

Also: Howard Read, Cheim & Read Gallery; Lenore Benson, the Fashion Group; Joan Munkacsi and Margit Erb, Howard Greenberg Gallery; George P. Lynes II; Robert Kaufman, Metropolitan Museum of Art; Irving Solero, Museum at the Fashion Institute of Technology; Mark Piel, the New York Society Library; Joshua Holdman, Robert Miller Gallery; Marianna Kleinman and Phillipe Garner, Sotheby's; Etheleen Staley and Taki Wise, Staley/Wise Gallery; and Kathie Hopkins, Time Pix.

I would like to thank Kathryn Abbe, Lillian Bassman, Jeremiah Goodman, Lizzie Himmel, David Joseph, John Mong, James Roper, Babs Simpson, Barbara Slifka, and Lucy White, who provided expertise and encouragement during the preparation of this book.

My special thanks to Mary McBride, who converted my words and layout design into a computer file—Mary made this daunting task a pleasant one.

I would also like to thank Elizabeth Parella for initially editing my text, and Jessica Fuller, my editor, for its final edit. Charles Miers, publisher, Bonnie Eldon, managing editor, Belinda Hellinger, production director, and Cathy Nastase of Universe Publishing were equally supportive in numerous ways. ∎

Mrs. Vreeland working in the studio with models and photographer George Hoyningen-Huene (left). Born a Baltic baron, Hoyningen-Huene left Paris in 1935 to photograph for *Bazaar* magazine in New York. PHOTOGRAPH: courtesy Staley/Wise Gallery.

BIBLIOGRAPHY

Baldwin, Billy. *Billy Baldwin Remembers*. New York: Harcourt Brace Jovanovich, 1974.

Ballard, Bettina. *In My Fashion*. New York: David McKay, 1967.

Beaton, Cecil. *The Glass of Fashion*. London: Weidenfield & Nicholson, 1954.

Chase, Edna Woolman, and Ilka Chase. *Always in Vogue*. Garden City, N.Y.: Doubleday & Company, 1954.

Dahl-Wolfe, Louise. *A Photographer's Scrapbook*. London: Quartet Books Limited, 1984.

Grand-Palais. *Hommage à Alexey Brodovitch*. Exhibition Catalogue, edited by Allan Porter and Georges Tourdman. Paris, 1982.

Harper's Bazaar. New York: Hearst Corporation, January 1936–June 1962.

Keenan, Brigid. *The Women We Wanted to Look Like*. New York: St. Martin's Press, 1977.

Kochno, Boris. *Christian Bérard*. New York: Panache Press, 1988.

Lawford, Valentine. "*Architectural Digest Visits Diana Vreeland*." *Architectural Digest*, September/October 1975, 74–79.

Philadelphia College of Art. *Alexey Brodovitch and His Influence*. Exhibition Catalogue, edited by George R. Bunker. Philadelphia, 1972.

Schiaparelli, Elsa. *Shocking Life*. New York: E. P. Dutton, 1954.

Snow, Carmel. *The World of Carmel Snow*. New York: McGraw Hill, 1962.

Sotheby's. *The Diana Vreeland Collection of Fashion Jewelry*. Exhibition Catalogue. New York, 1987.

Sotheby's. *Property of the Estate of Diana Vreeland*. Exhibition Catalogue. New York, 1990.

Tapert, Annette, and Diana Edkins. *The Power of Style*. New York: Crown Publishers, 1994.

Trahey, Jane. *Harper's Bazaar/100 Years of the American Female*. New York: Random House, 1967.

Vreeland, Diana. *Allure*. Garden City, N.Y.: Doubleday & Company, 1980.

_____. *D.V.* New York: Alfred A. Knopf, 1984.

Weymouth, Lally. "A Question of Style: A Conversation with Diana Vreeland." *Rolling Stone*, 11 August 1977, 38–54.

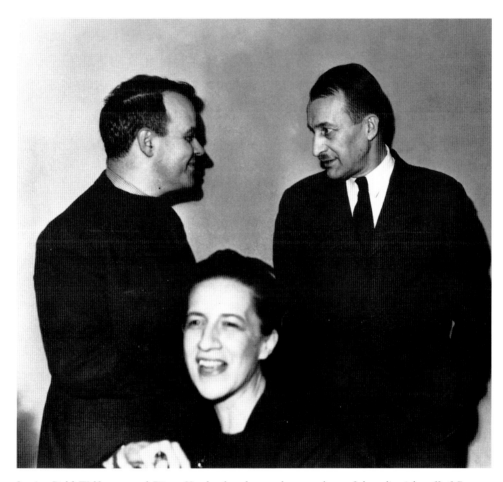

Louise Dahl-Wolfe snapped Diana Vreeland and two other members of the editorial staff of *Bazaar*, George Davis (left), and émigré art director Alexey Brodovitch during a meeting at her 57th Street studio. PHOTOGRAPH: courtesy Staley/Wise Gallery.

All my life I've pursued
the perfect red.
I can never get painters
to mix if for me.
About the best red is to
copy the color of a child's cap
in any Renaissance portrait.

—DV

INDEX